THE TRUE GHOST STORY ADULT COLORING BOOK:

INSPIRED BY
JIM HAROLD'S CAMPFIRE

JIM HAROLD
LEN PERALTA, ILLUSTRATOR

NOTES:

THE IMAGES INSIDE THIS ADULT COLORING BOOK WERE INSPIRED BY JIM HAROLD'S POPULAR SERIES OF PODCASTS AND BOOKS ENTITLED *JIM HAROLD'S CAMPFIRE.*

YOU CAN FIND JIM'S FREE PODCASTS AT JIMHAROLD.COM, iTUNES, SPOTIFY AND WHEREVER FINE PODCASTS ARE HEARD.

YOU CAN FIND HIS BEST SELLING SERIES OF CAMPFIRE BOOKS AT AMAZON.COM AND JIMHAROLDBOOKS.COM

YOU CAN LEARN MORE ABOUT LEN PERALTA'S ARTWORK AT LENPERALTA.COM

PLEASE SEE THE KEY AT THE END OF THIS BOOK WHICH EXPLAINS MORE ABOUT EACH IMAGE INCLUDING THE PODCAST EPISODE AND BOOK THAT INSPIRED EACH VIGNETTE.

ISBN-10:1-945676-01-9
ISBN-13:978-1-945676-01-7

DEDICATIONS:

From Jim Harold:

To Dar, Cass & Nat: I Love You All.

To Len: It was an honor to work on this project with you.
You are a hard-working and talented man.
Hope we can do it again!

From Len Peralta:

Thanks to my family, especially my wife Nora
who is always up for a good strange tale.

Thanks to Jim Harold for giving me the opportunity
to fuse two of my favorite things together:
artwork and spooky tales. Here's to many more!

COLOR TEST PAGE

COLOR TEST PAGE

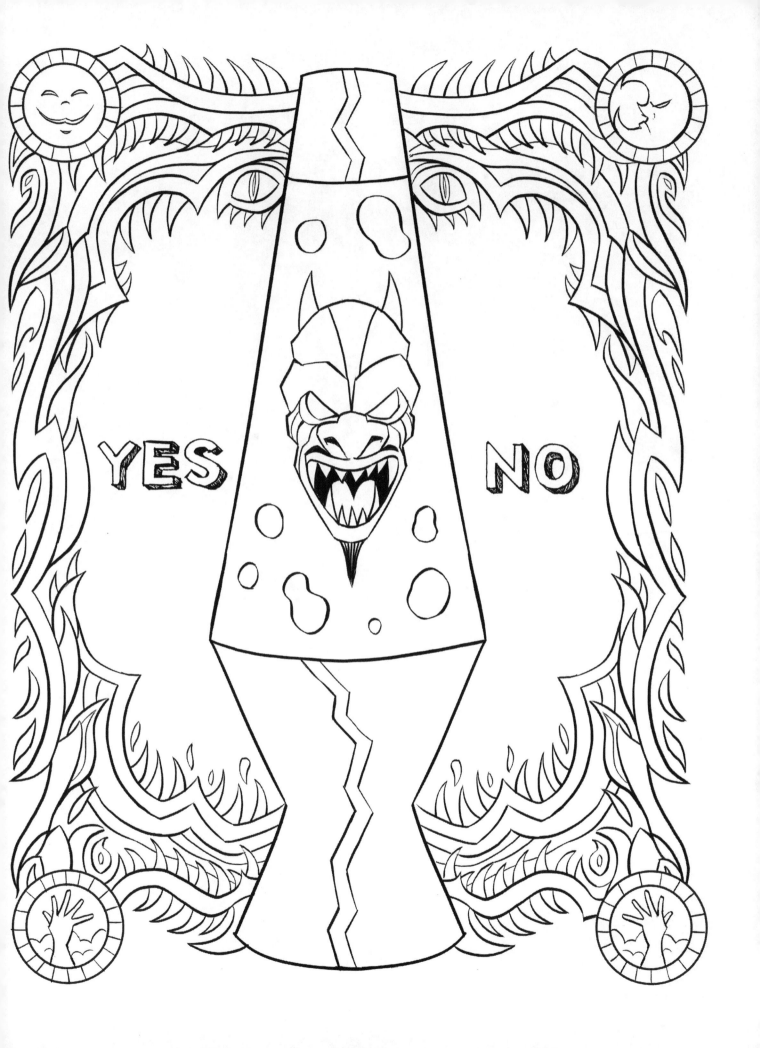

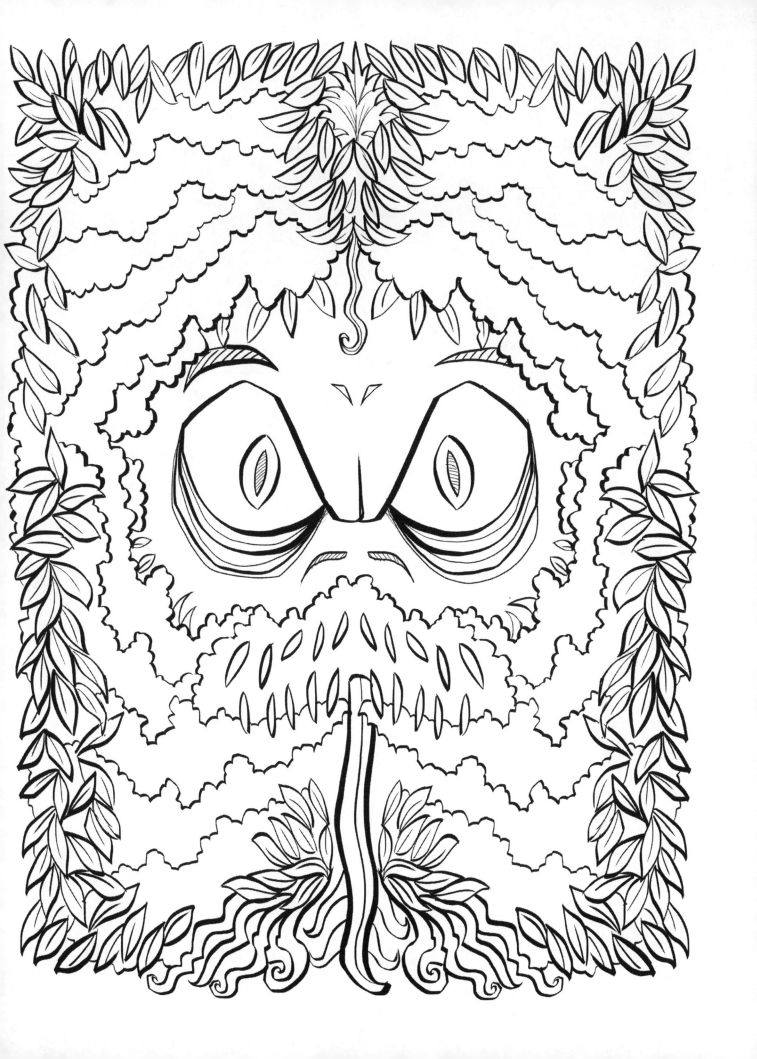

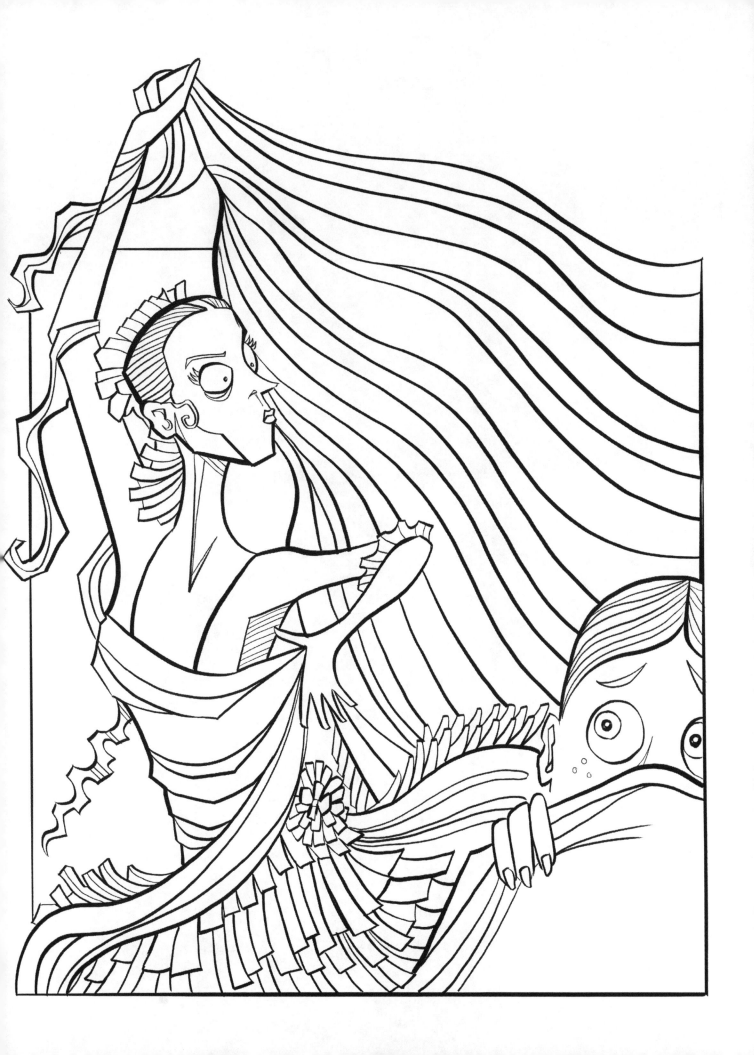

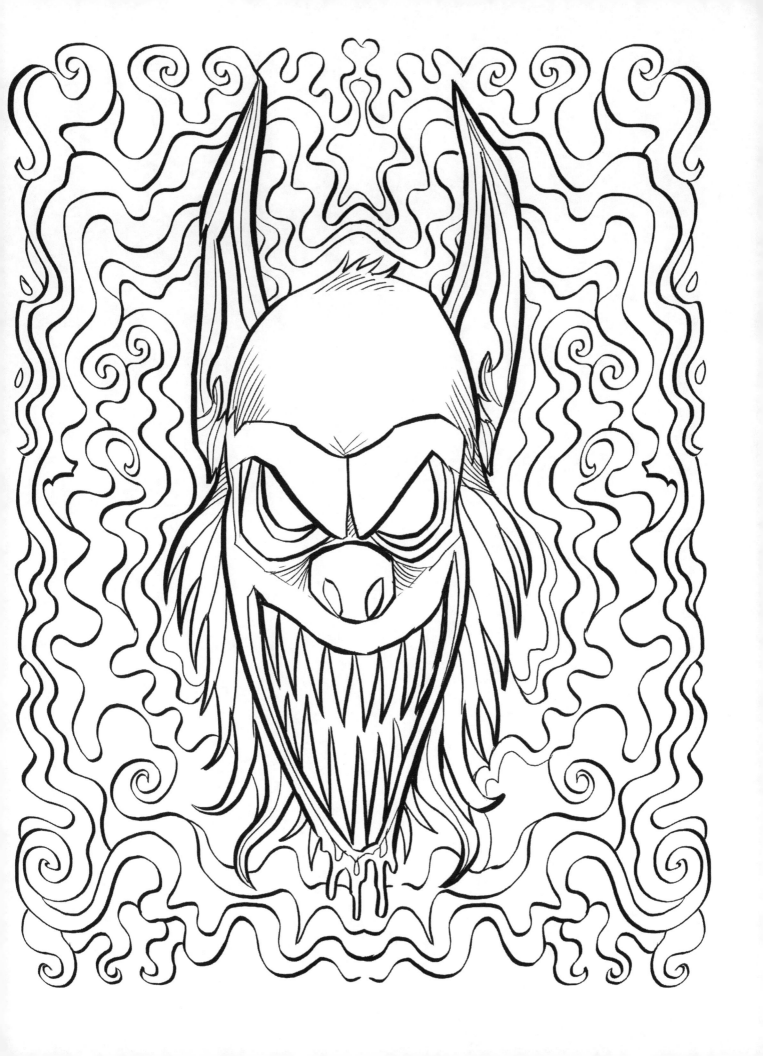

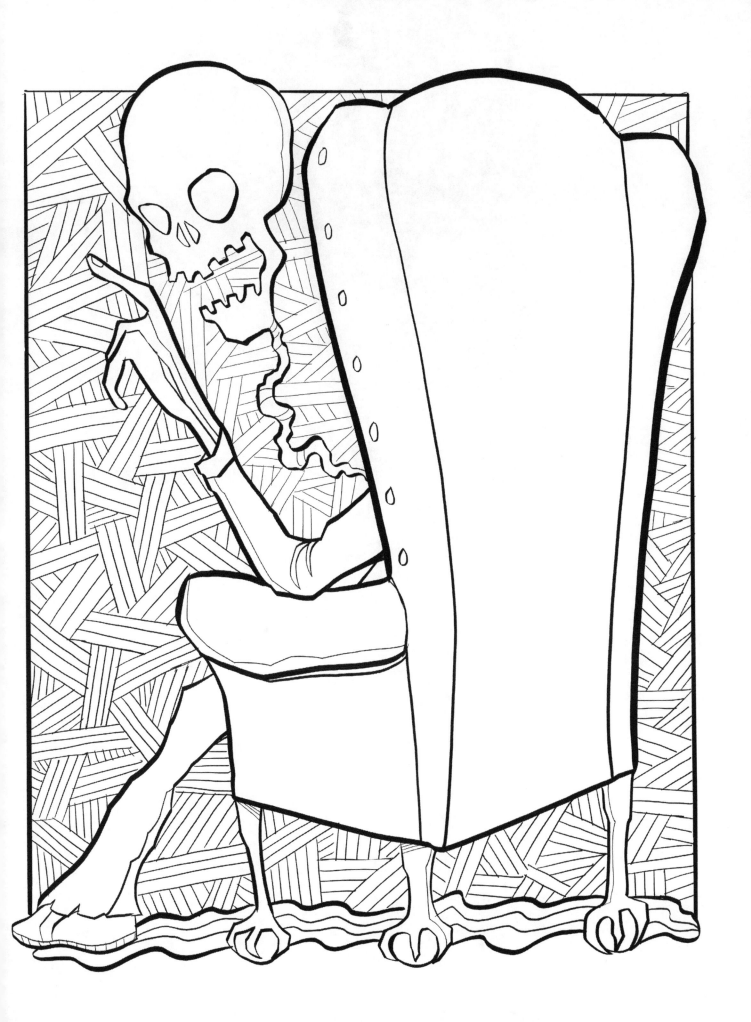

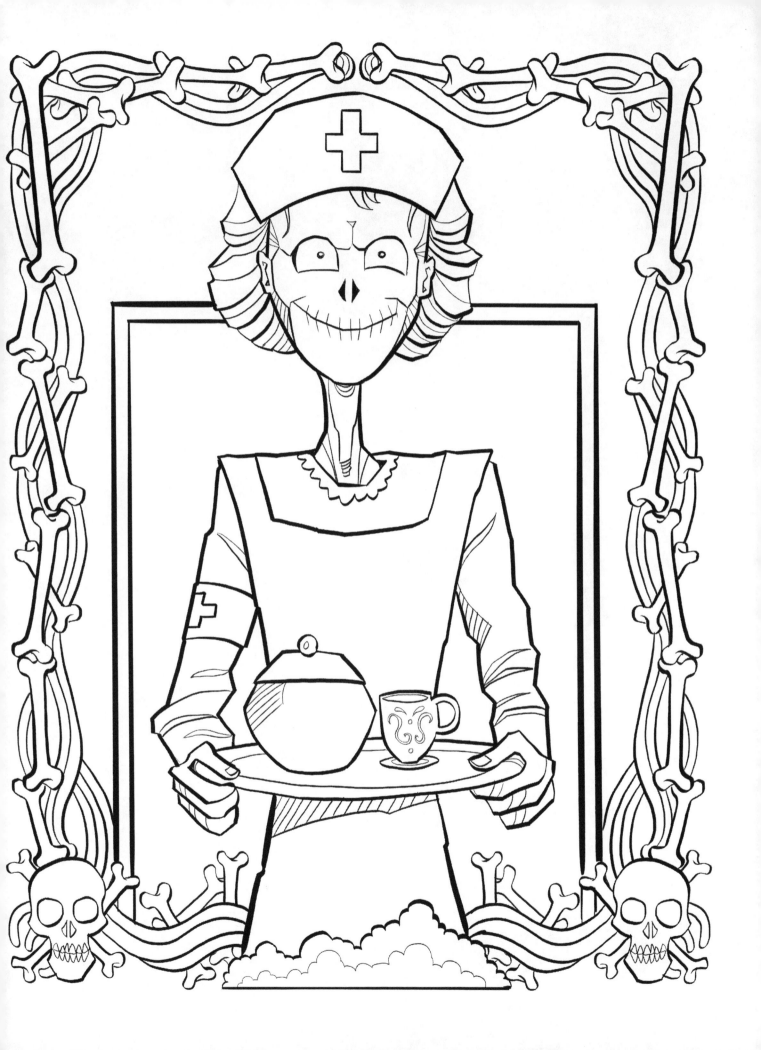

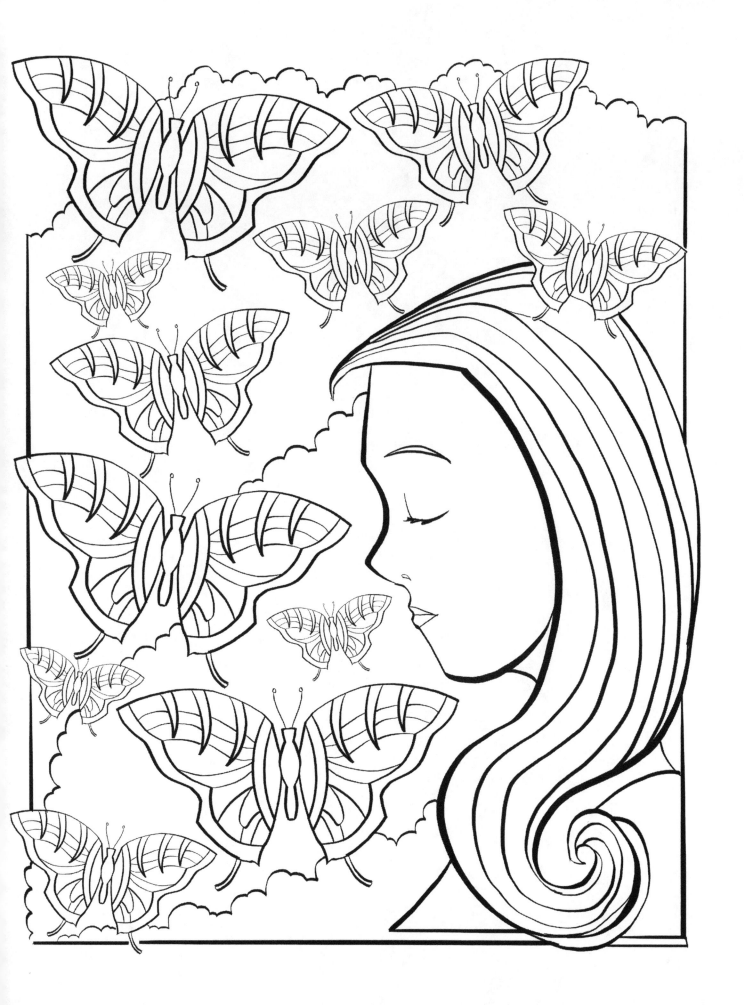

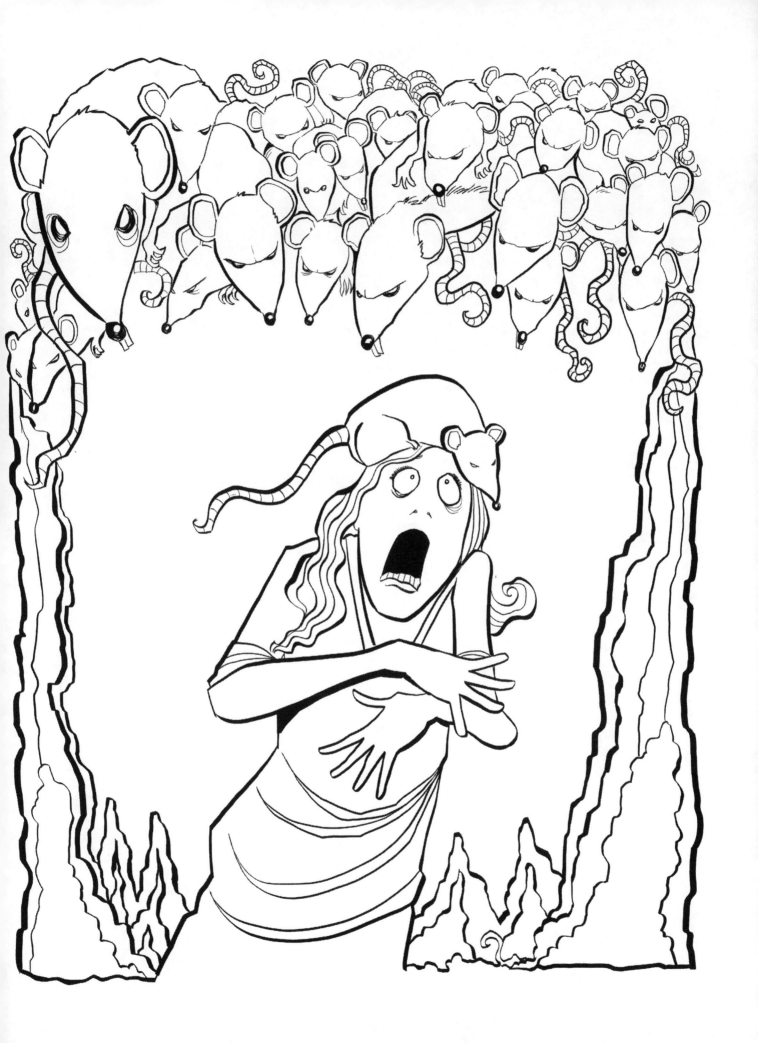

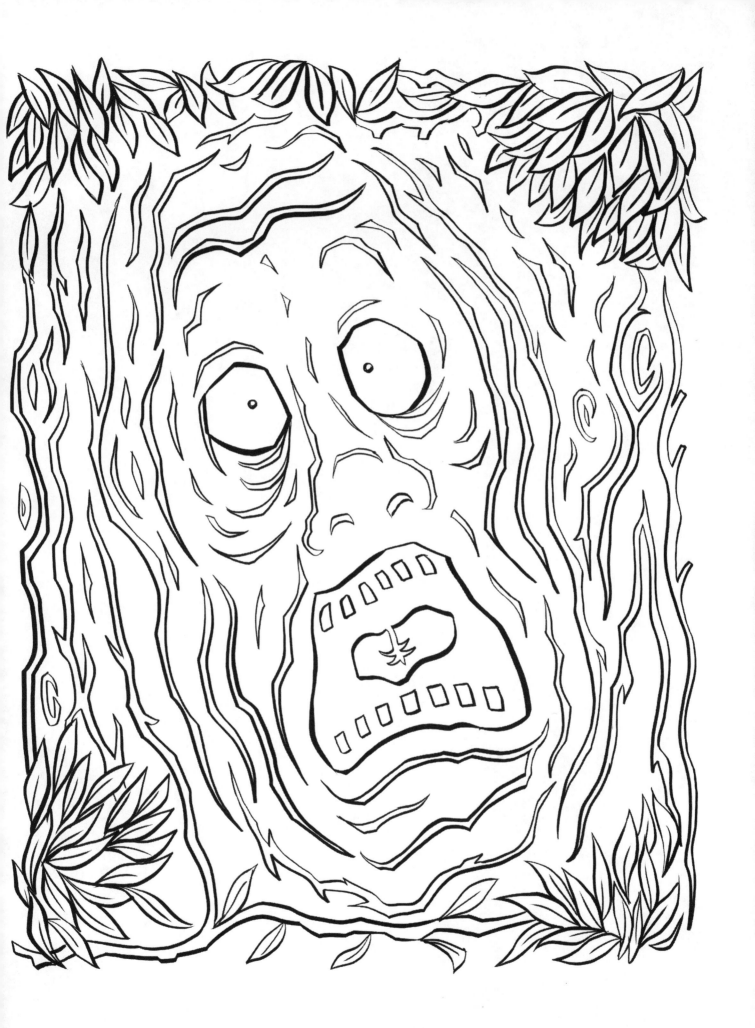

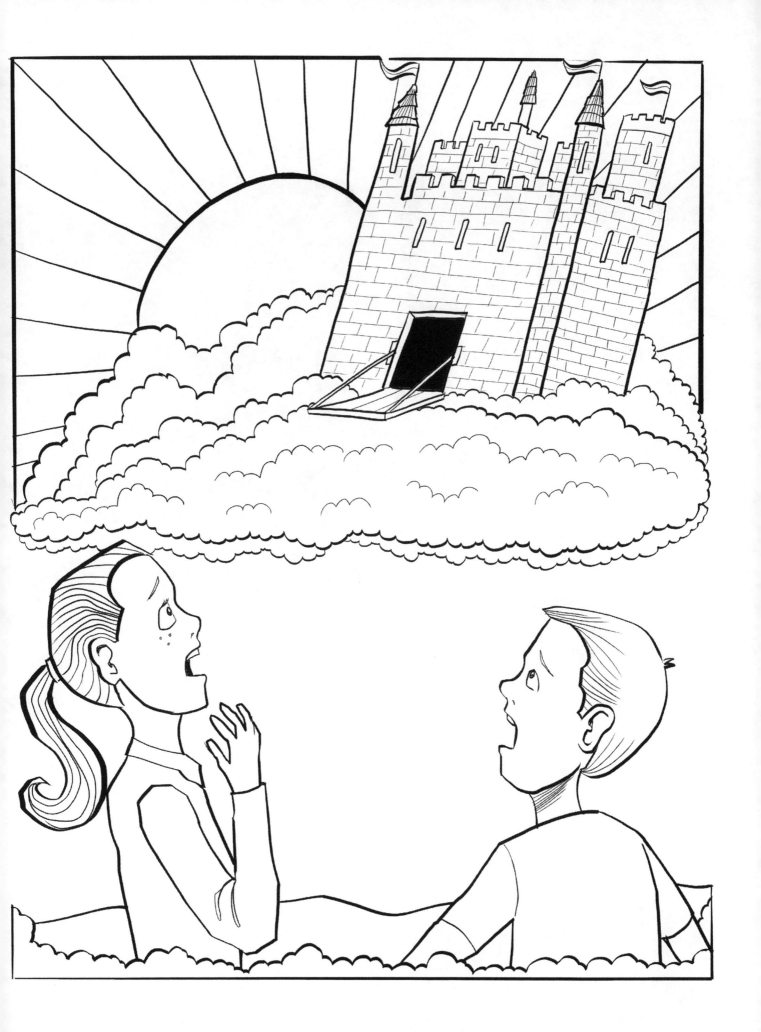

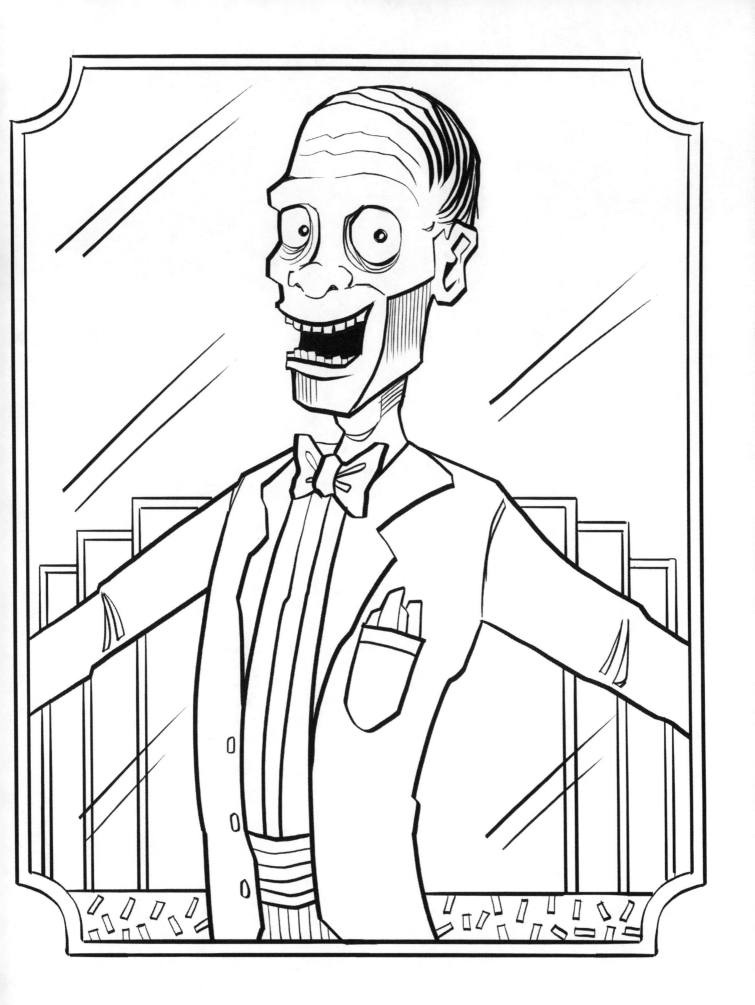

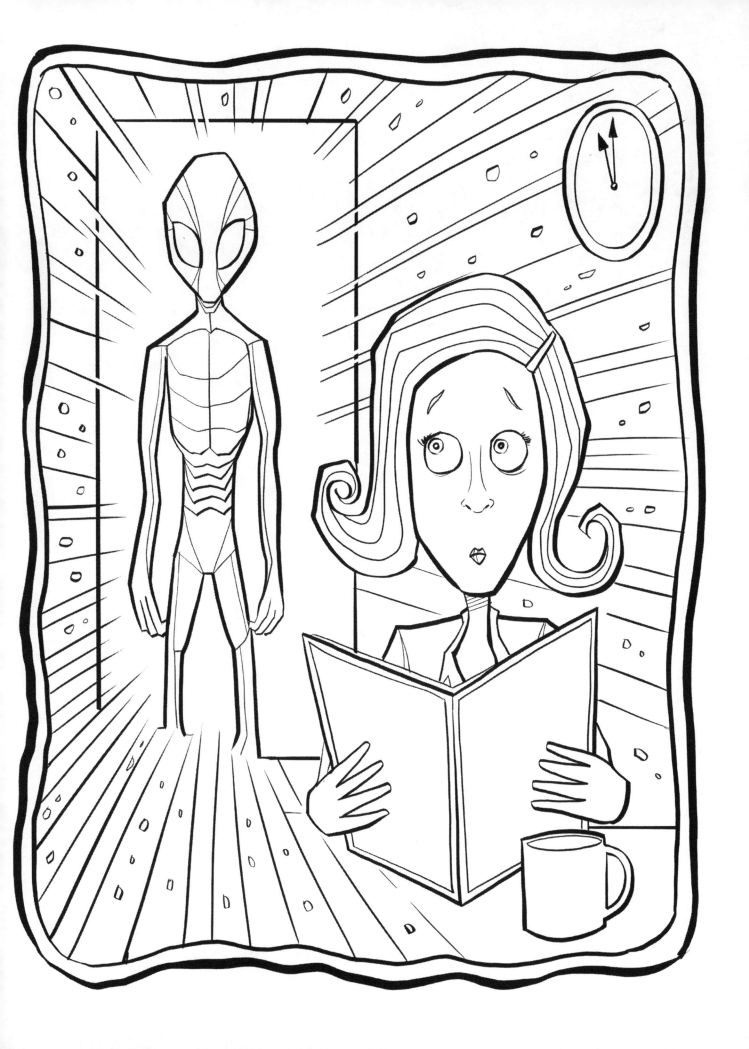

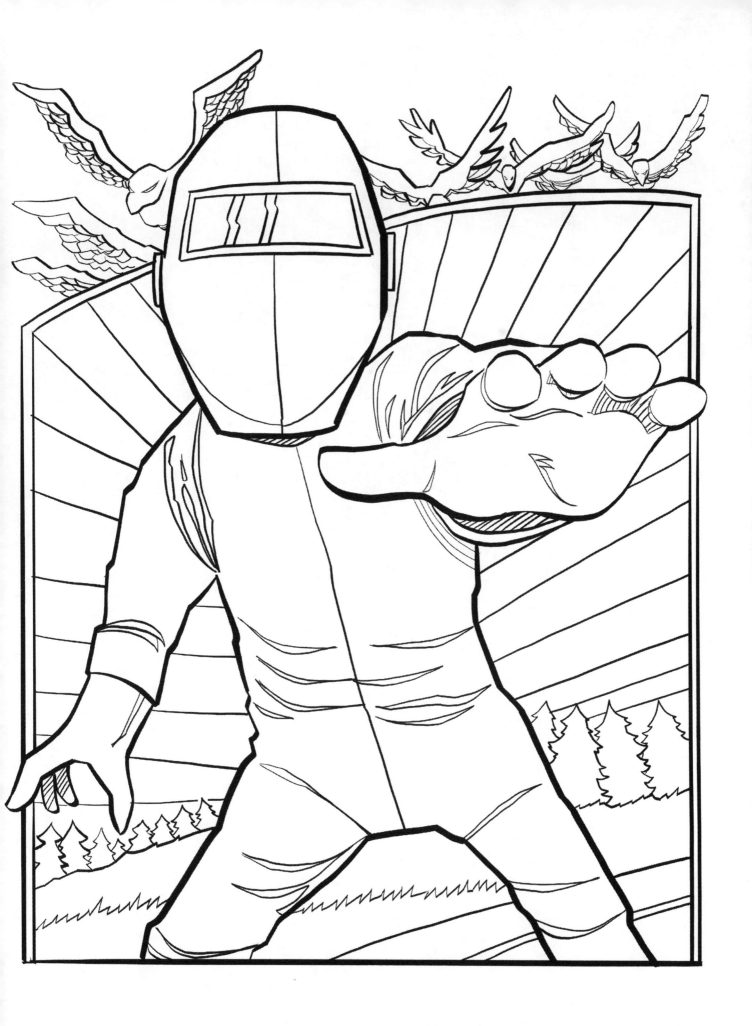

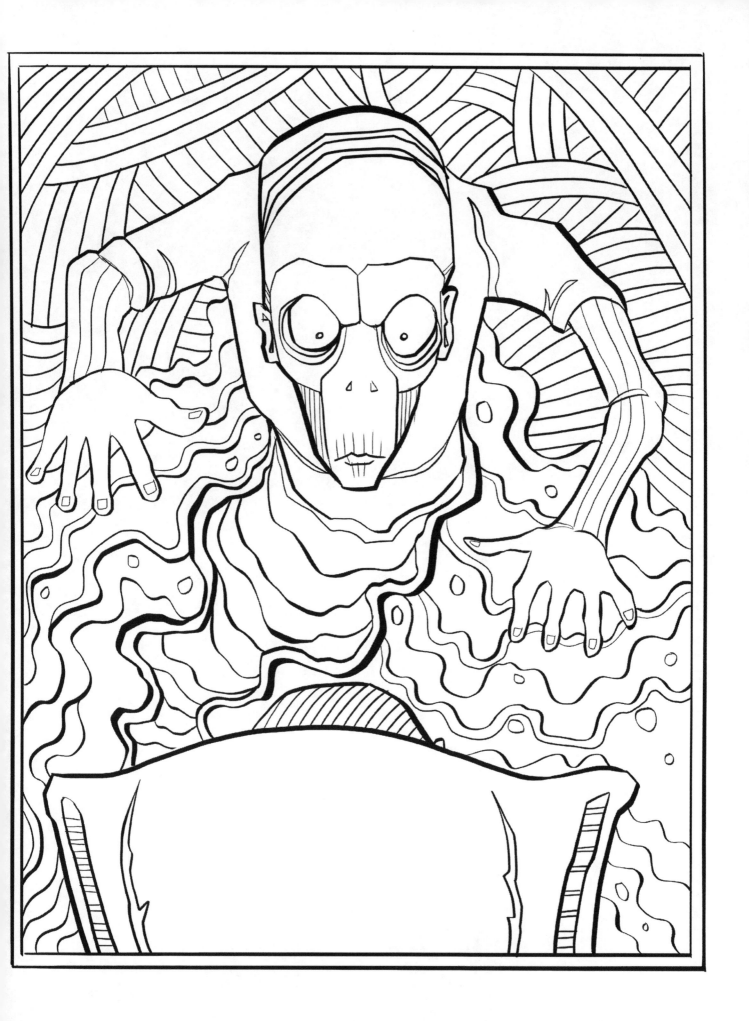

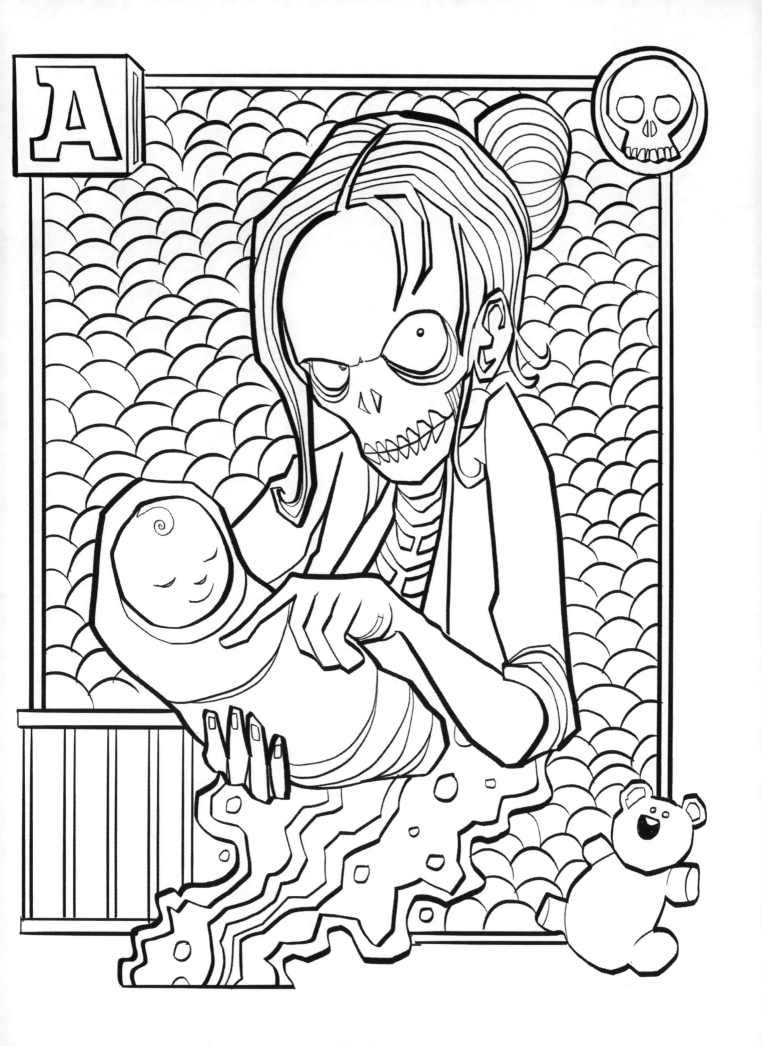

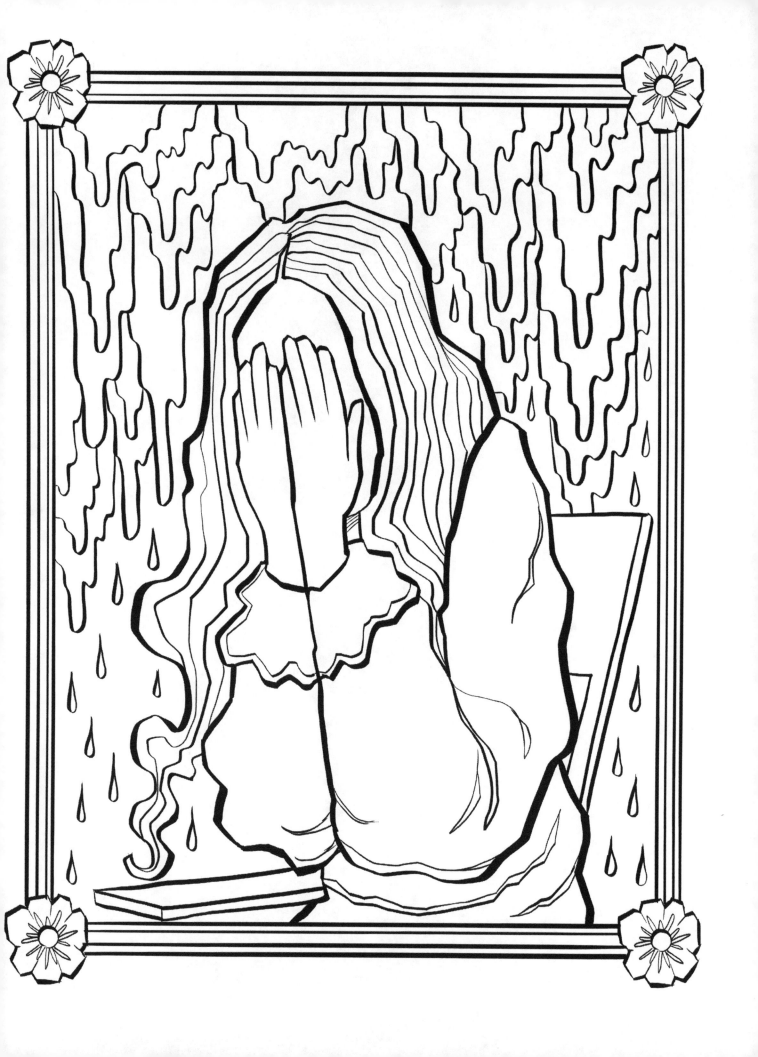

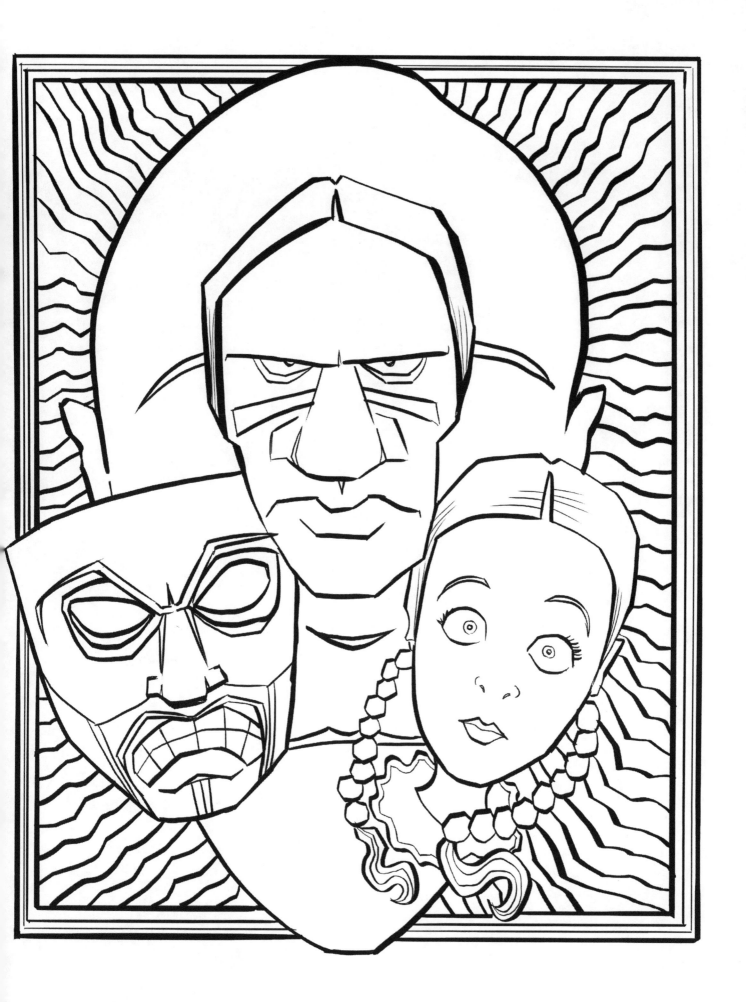

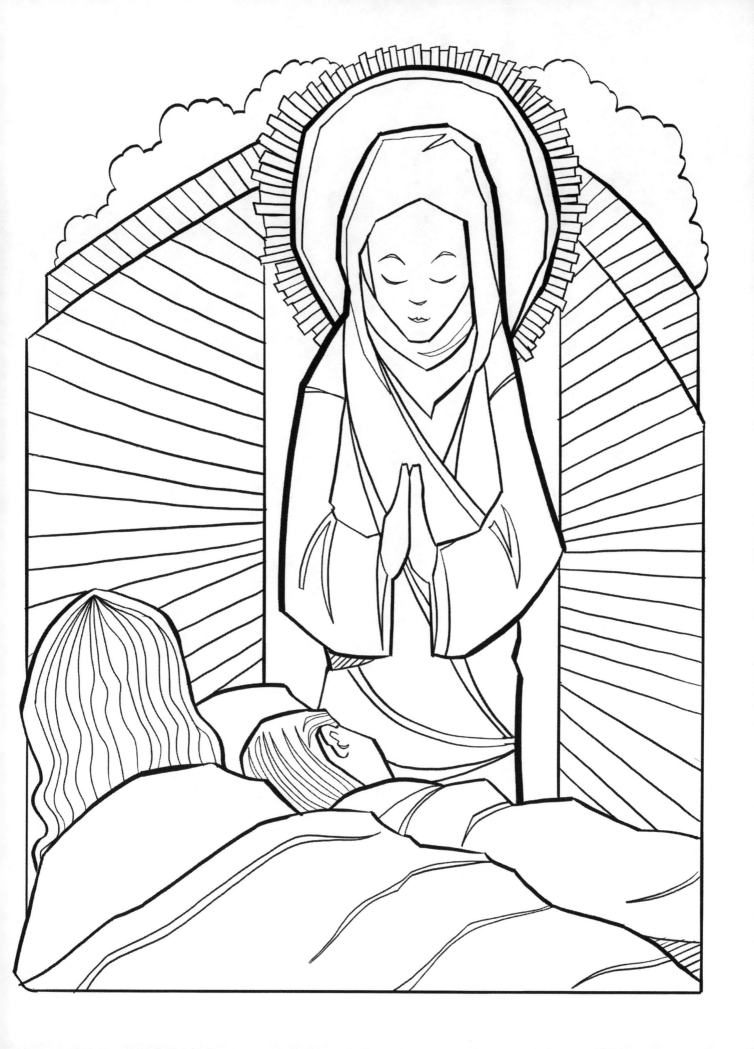

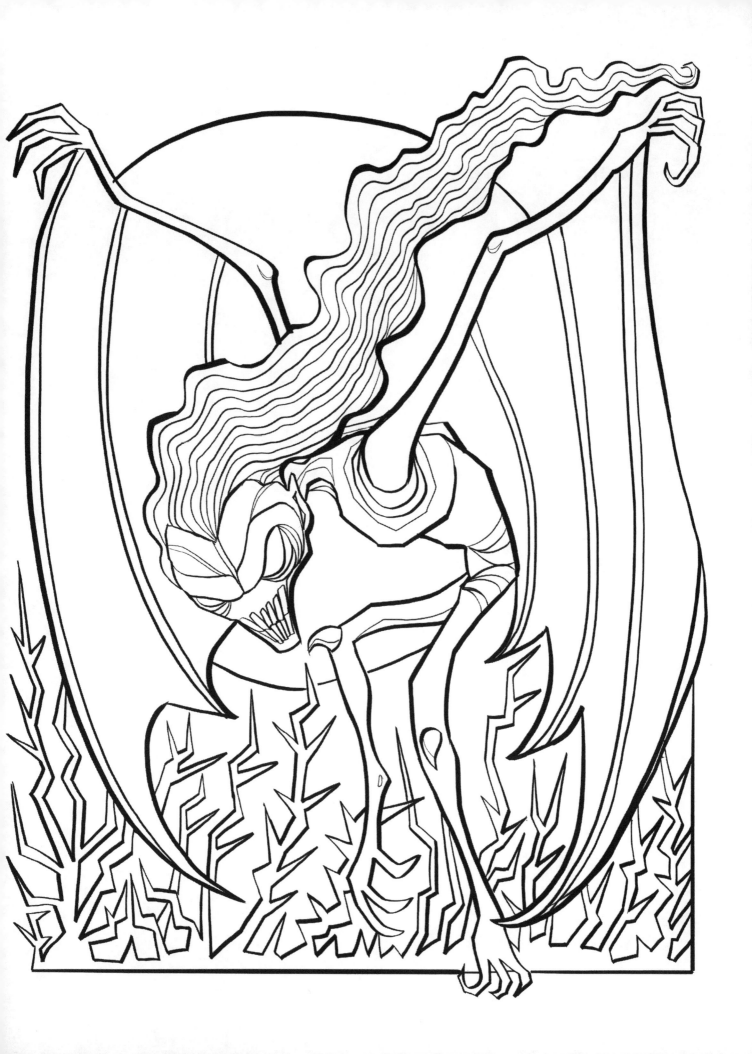

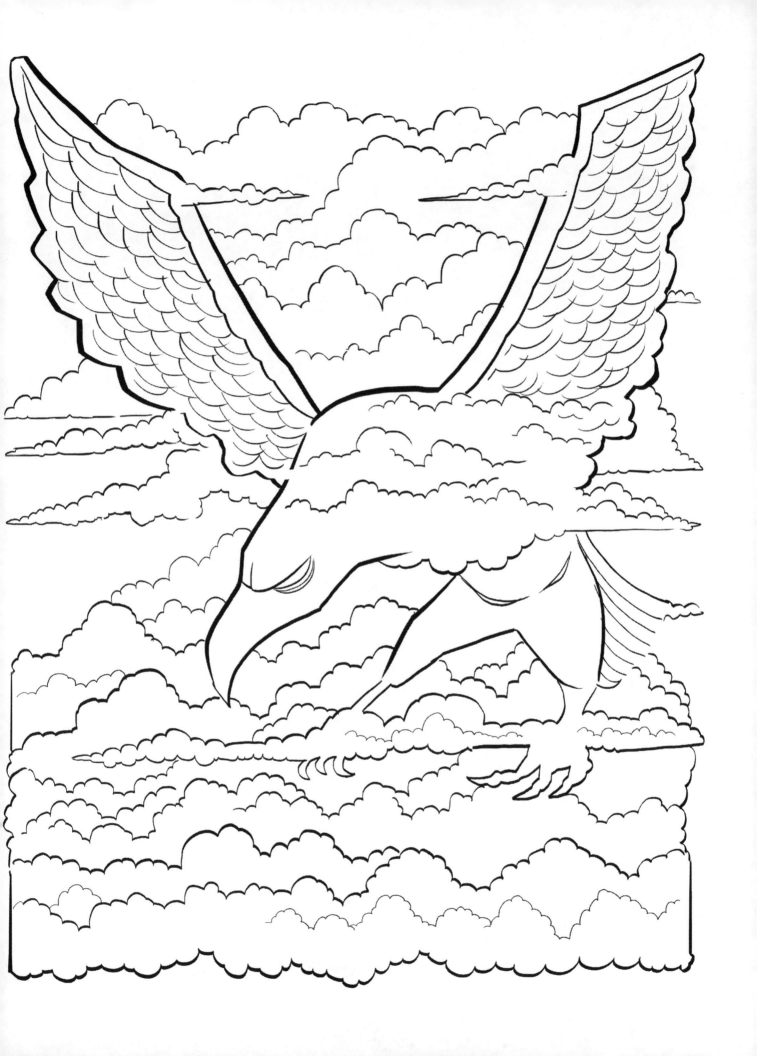

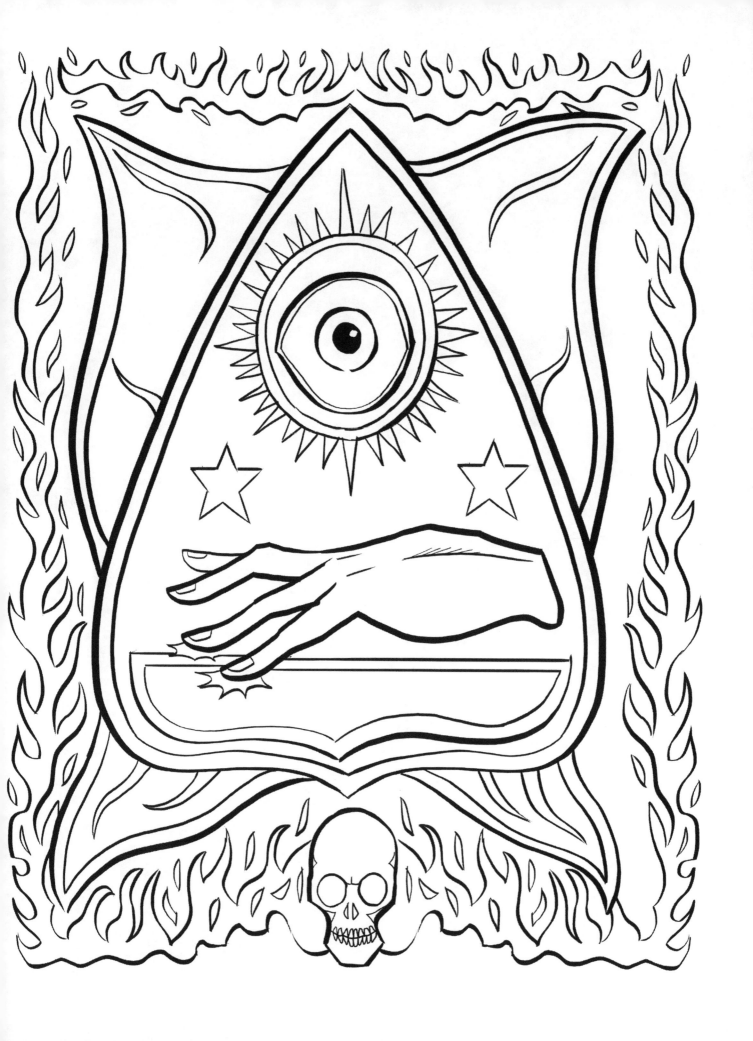

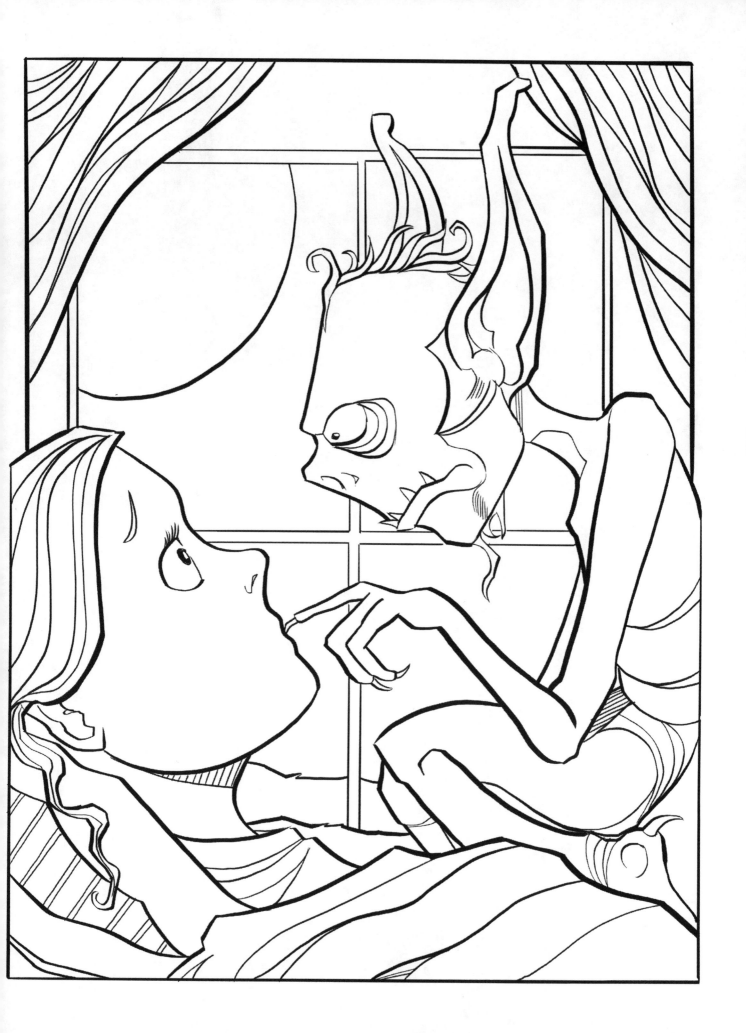

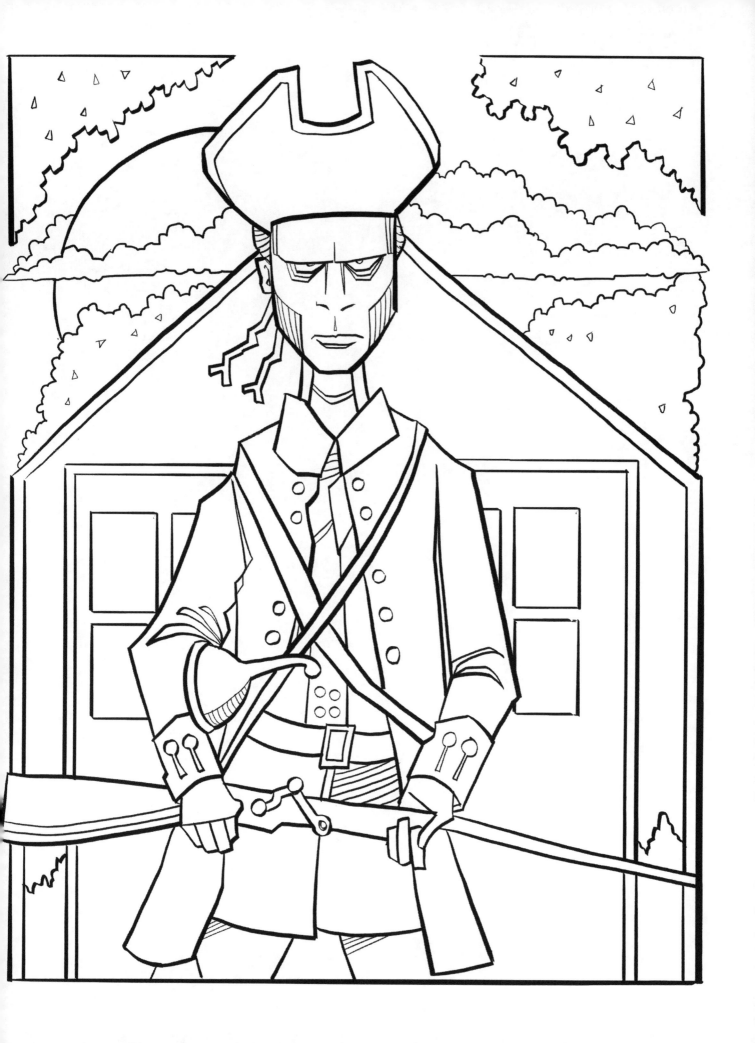

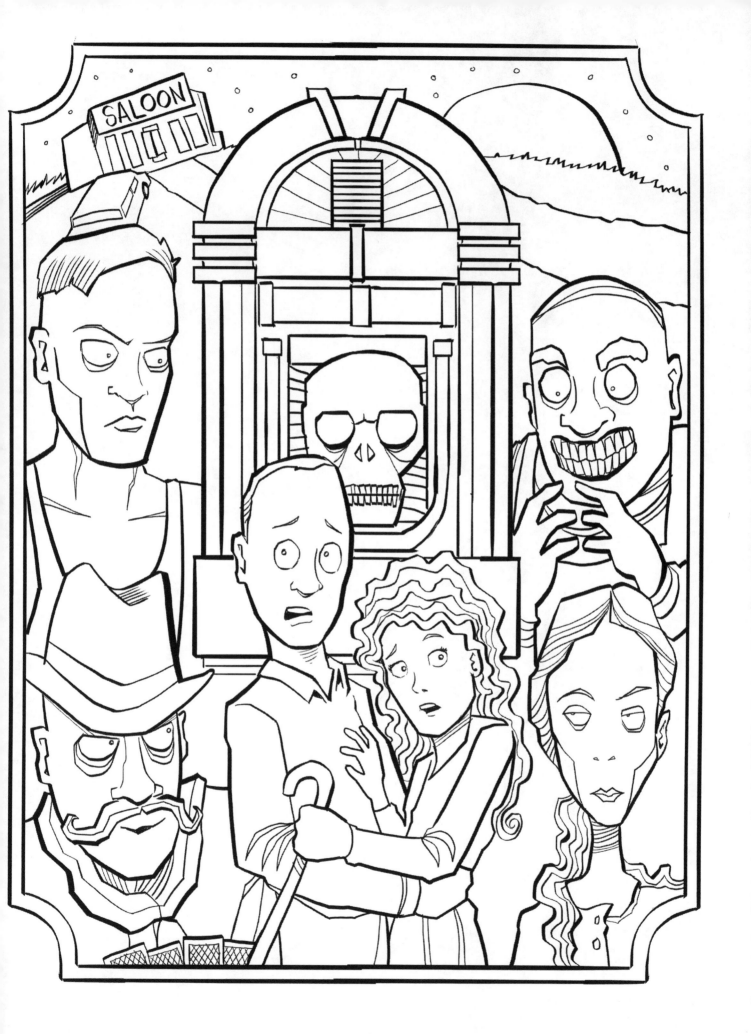

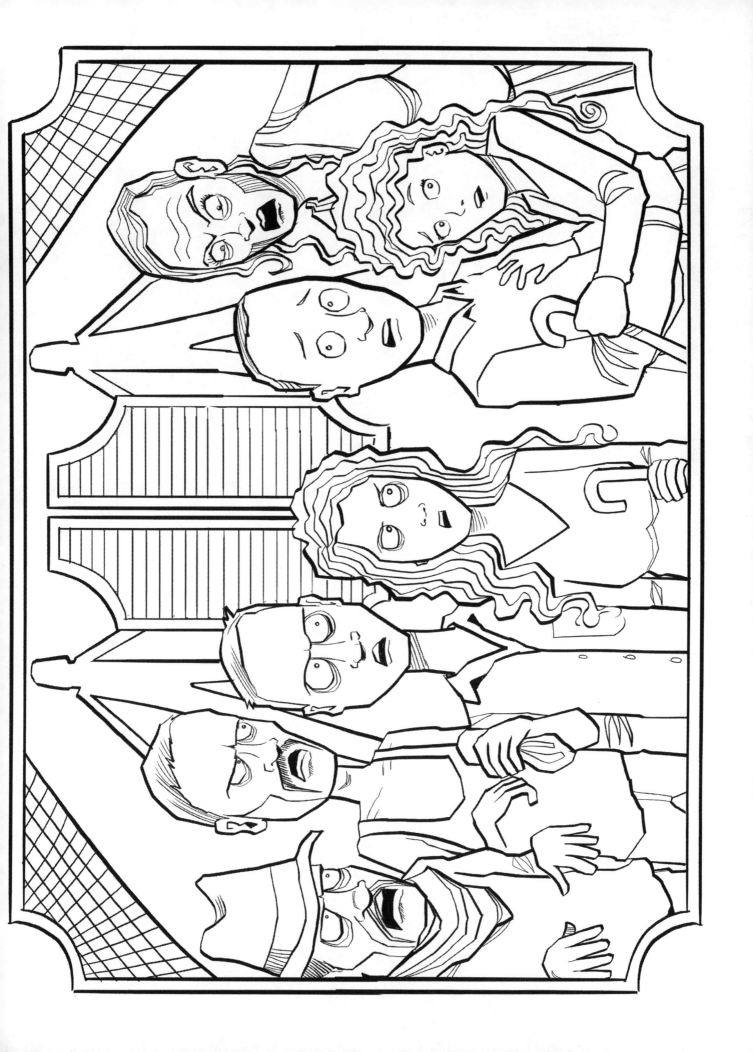

FINAL THOUGHTS:

Thanks for for bringing these stories to life with your coloring.
I hope that you enjoyed the book and Len Peralta's amazing artwork.

For your convenience, I've included information below on how you can stay
up-to-date with everything that Len and myself are working on these days.

Thanks - Jim Harold

THE IMAGES INSIDE THIS ADULT COLORING BOOK WERE INSPIRED BY
JIM HAROLD'S POPULAR SERIES OF PODCASTS AND BOOKS ENTITLED
JIM HAROLD'S CAMPFIRE.

YOU CAN FIND JIM'S FREE PODCASTS AT JIMHAROLD.COM, iTUNES, SPOTIFY
AND WHEREVER FINE PODCASTS ARE HEARD.

YOU CAN FIND HIS BEST SELLING SERIES OF CAMPFIRE BOOKS AT
AMAZON.COM AND JIMHAROLDBOOKS.COM

YOU CAN LEARN MORE ABOUT LEN PERALTA'S ARTWORK AT:
LENPERALTA.COM

IMAGE KEY:

BELOW IS A LISTING OF THE IMAGES IN THIS BOOK. INCLUDE IS TITLE, A BRIEF SYNOPSIS, AND THE PODCAST EPISODE (ALONG WITH THE CORRESPONDING BOOK CHAPTER) THAT INSPIRED IT.

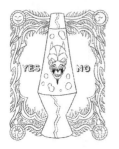

LUCIFER IN THE LAMP - A teenager plays with a Ouija board and you'll never guess who visits via an image in a Lava Lamp.

Campfire Podcast Episode = 8
Book = *True Ghost Stories: Jim Harold's Campfire 1*, Prologue

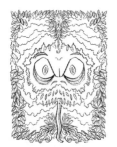

OL' RED EYES - When you stare into the abyss, sometimes it stares back!

Campfire Podcast Episode = 8
Book = *True Ghost Stories: Jim Harold's Campfire* 1, Chapter 32

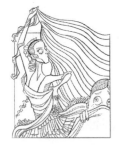

THE LAMP LADY COMES AT NIGHT - A terrifying visitor haunts a young girl every night.

Campfire Podcast Episode = 19
Book = *True Ghost Stories: Jim Harold's Campfire 2*, Prologue

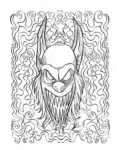

BEAST IN THE FOG = One of our British storytellers comes face to face with this terrifying spectre.

Campfire Podcast Episode = 47
Book = *True Ghost Stories: Jim Harold's Campfire 2*, Chapter 54

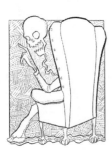

THE RECLINING GHOST = A gifted recliner brings a little something extra with it...a haunting!

Campfire Podcast Episode = 61
Book = *True Ghost Stories: Jim Harold's Campfire 2*, Chapter 1

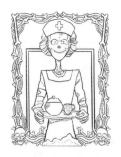

WOULD YOU LIKE A SPOT OF TEA? - A British woman in hospital encounters a friendly but very strange nurse.

Campfire Podcast Episode = 12
Book = *True Ghost Stories: Jim Harold's Campfire 1*, Chapter 1

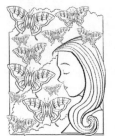

LOVE IS LIKE A BUTTERFLY - A recently passed grandpa delivers a message via a swarm of beautiful butterflies.

Campfire Podcast Episode = 25
Book = *True Ghost Stories: Jim Harold's Campfire 1*, Chapter 36

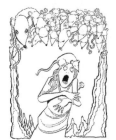

OH, RATS! - The universe doles out karmic justice to an unkind stepmother when rats start falling out of the sky!

Campfire Podcast Episode = 8
Book = *True Ghost Stories: Jim Harold's Campfire 1*, Chapter 58

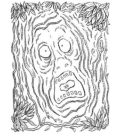

THE TREE WITH A FACE - A young man gets quite a surprise while walking in the woods.

Campfire Podcast Episode = 7
Book = *True Ghost Stories: Jim Harold's Campfire 1*, Chapter 61

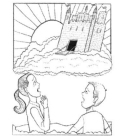

CASTLE IN THE SKY - A girl sees something inexplicable in the sky.

Campfire Podcast Episode = 44
Book = *True Ghost Stories: Jim Harold's Campfire 2*, Chapter 56

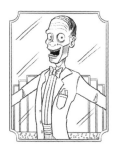

WHAT A MIRROR IMAGE WE ARE = A tuxedo wearing apparition haunts a vacation home.

Campfire Podcast Episode = 59
Book = *True Ghost Stories: Jim Harold's Campfire 2*, Chapter 65

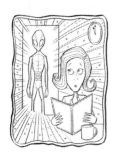

A LIGHT THAT WASN'T QUITE RIGHT - A UFO and missing time highlight this terrifying tale.

Campfire Podcast Episode = 3
Book = *True Ghost Stories: Jim Harold's Campfire 1*, Chapter 28

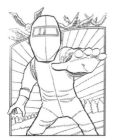

IT LIT UP THE WHOLE SKY = A couple encounters high strangeness on a late night drive.

Campfire Podcast Episode = 16
Book = *True Ghost Stories: Jim Harold's Campfire 1*, Chapter 67

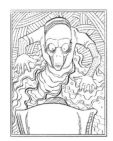

THERE'S SOMEONE IN HERE = Two brothers are visited by a ghost on different nights.

Campfire Podcast Episode = 16
Book = *True Ghost Stories: Jim Harold's Campfire 1*, Chapter 68

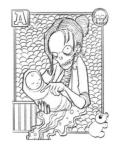

GHOST NANNY = Who's minding the baby? Why, it's a ghost nanny!

Campfire Podcast Episode = 40
Book = *True Ghost Stories: Jim Harold's Campfire 2*, Chapter 27

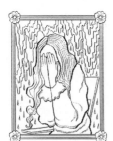

NOT JUST ANY PAINTING = A second hand painting comes to life in a terrifying way!

Campfire Podcast Episode = 40
Book = *True Ghost Stories: Jim Harold's Campfire 2*, Chapter 28

CHANGING FACES = While enjoying an afternoon tea, a man sees his friend's face morph before his eyes.

Campfire Podcast Episode = 66
Book = *True Ghost Stories: Jim Harold's Campfire 2*, Chapter 31

MARY VISITS = The Virgin Mary appears with a sign from a loved one passing over.

Campfire Podcast Episode = 22
Book = *True Ghost Stories: Jim Harold's Campfire 2,* Chapter 29

LA CHUSA = The "mythical" female entity makes a real life appearance!

Campfire Podcast Episode = 21
Book = *True Ghost Stories: Jim Harold's Campfire 2,* Chapter 51

THE GIANT EAGLE = A storytellers sees a REALLY big eagle in the American Southwest.

Campfire Podcast Episode = 46
Book = *True Ghost Stories: Jim Harold's Campfire 2,* Chapter 59

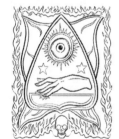

THE WALKING OUIJA = A Ouija board comes to life and walks!

Campfire Podcast Episode = 51
Book = *True Ghost Stories: Jim Harold's Campfire 2,* Chapter 64

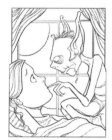

HERMAN = A strange entity visits at bedtime.

Campfire Podcast Episode = Was not on a program, submitted story in writing.
Book = *True Ghost Stories: Jim Harold's Campfire 1,* Bonus Chapter (end of book)

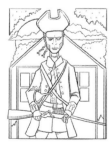

MINUTEMAN ON GUARD = A Revolutionary War ghost appears in modern day New England

Campfire Podcast Episode = 4
Book = *True Ghost Stories: Jim Harold's Campfire 1,* Chapter 6

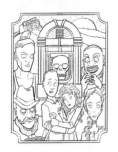

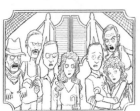

THE ROADHOUSE SALOON - A woman and a friend visit a weird bar where they nearly end up trapped as images in a mysterious mural on the wall. A story so great, we created two images for it!

Campfire Podcast Episode = 110
Book = *True Ghost Stories: Jim Harold's Campfire 3*, Chapter 69

Made in United States
Troutdale, OR
11/25/2023

14903493R00038